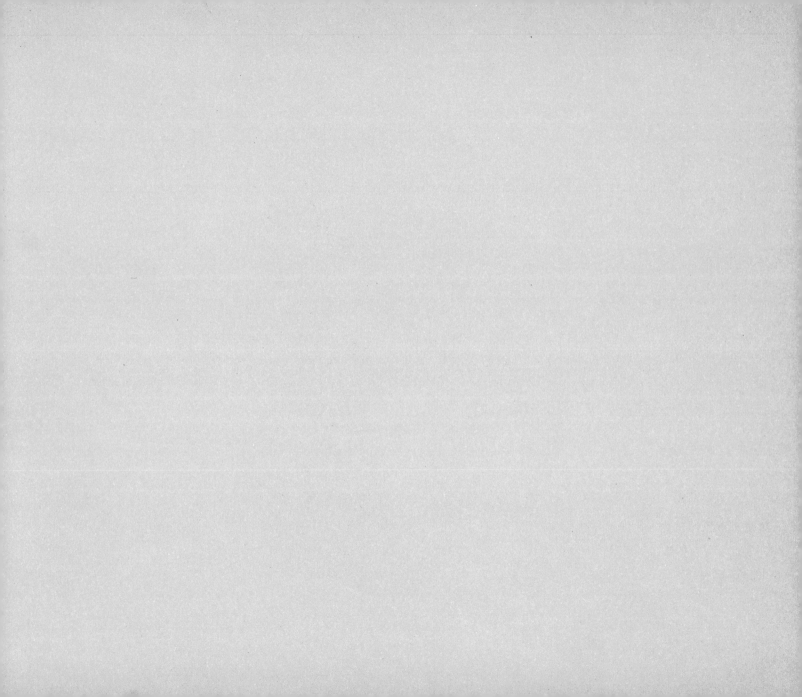

MONET'S GARDENS

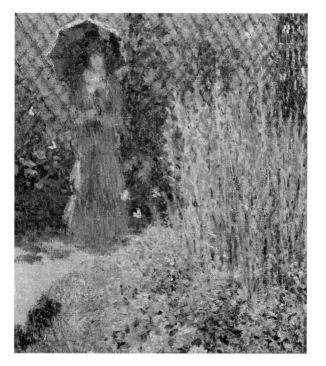

Nyphaéas: Harmony in Pink, 1900

MONET'S GARDENS

PAVILION

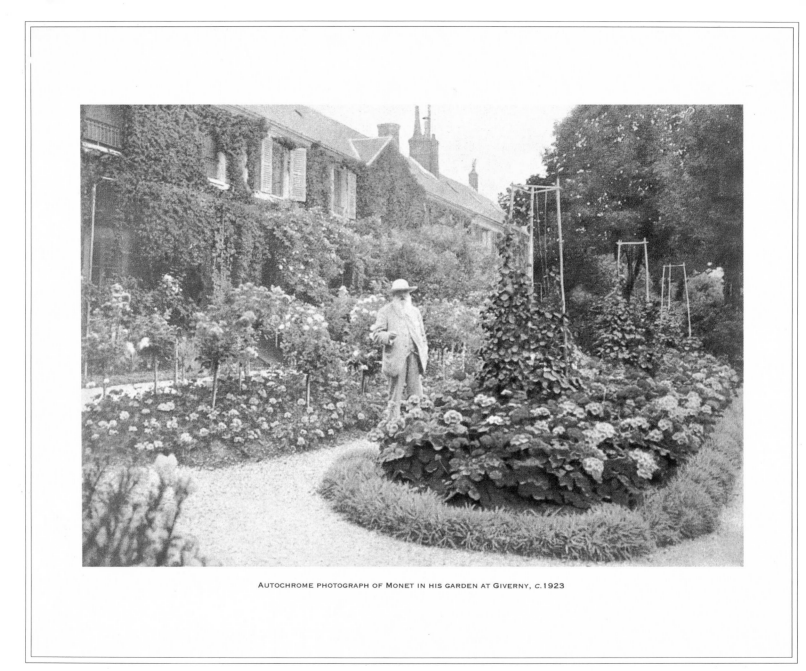

Autochrome photograph of Monet in his garden at Giverny, c.1923

INTRODUCTION

At the moment in history when industrialization had begun to jeopardize the fragile relationship between man and nature, Monet's paintings provided audiences, dealers and critics with a means of visual contemplation of the natural world. Debates raged in the art press throughout his career as to the motivation and meaning of his paintings, unaided by Monet who was too engaged in the actual production of his work to enter into discussion of their theoretical significance. Monet is reported to have said that he owed his career in painting to a love of flowers, but his works transcend such a simple explanation and testify to his constant search to find a new way of representing the world around him. The progress and success of this project, which continued to his death, can be traced through the many paintings he made of his gardens – the special places where nature met his life.

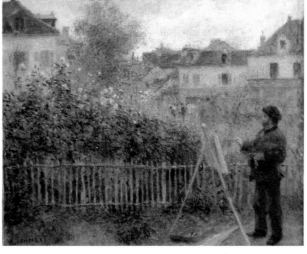

RENOIR'S PORTRAIT OF MONET PAINTING IN HIS GARDEN AT ARGENTEUIL, 1873

Monet's desire to live and work away from Paris, first at Argenteuil and later at Giverny, is sometimes attributed to his lack of money and more often to the accessibility of fields, trees and water as subject matter for his paintings.

But his decision was not unusual in the latter half of the nineteenth century. Industrialization had led to an increase in population in the cities, the physical structure of Paris's apartment blocks and boulevards was changing at the hand of Baron Haussmann, and the development of the railway networks facilitated escape from the new tensions of urban life. Most people made Sunday excursions to riverside restaurants such as La Grenouillère, or summer trips to the coast at Honfleur or Le Havre. But the rapid changes taking place in the capital were leading many of its middle-class, or *bourgeois*, citizens to purchase small pockets of property in the countryside, either as holiday or permanent homes. Social observers recorded this phenomenon, often critically, concerned by the potential damage to land and rural life. As early as 1860 Eugene Chapus commented in *Le Sport*: 'One of the pronounced characteristics of our present Parisian society is that everyone in the middle class wants to have his little house with trees, roses, dahlias; his big or little garden.'

In 1871, after the disruption caused by the Franco-

Prussian War and his stay in London, Monet moved to Argenteuil. With him were Camille Doncieux, who had become Madame Monet the year before, and their four-year-old son, Jean. There followed a series of paintings of his family and their friends in the garden, such as *Camille Reading* of 1872 and *Monet's Family in the Garden* of 1873. These images both depict the private world of the artist within the confines of the garden walls and act as a visual record of the urban bourgeoisie in the organized natural habitat of their constructed paradise.

It was during this time that the work of Monet and his contemporaries was named as a movement which has become one of the most famous in the history of art. Frustrated by the constant rejection of their work by the jury of the official annual Salon, Monet, Renoir, Sisley, Berthe Morisot and others organized an exhibition of their

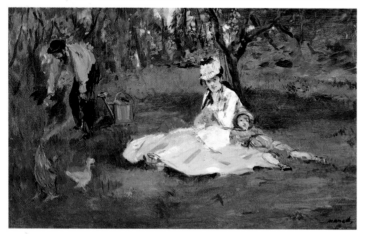

EDOUARD MANET'S *THE MONET FAMILY IN THEIR GARDEN AT ARGENTEUIL*, 1874

own at the Paris studio of the photographer Nadar. The great deal of attention that they received was not all favourable, and a debate broke out which was essentially between those who celebrated the break from tradition represented in the new subject matter and techniques, and those who accused the paintings of being no more than sketchy 'impressions'.

The Impressionists' attempts to develop a way of painting which expressed the truth of the contemporary world and their own, direct responses to what they saw around them, threatened the existence of the established style of the Academy, and they were unable to sell much of their work. Monet and his friends, except for painters such as Bazille whose *haute bourgeois* family could afford to support him, relied heavily on art dealers whose faith in them meant that they would advance money on sales and help out in desperate times. Despite the apparent prosperity and abundance we see in Monet's paintings of this period, such as *The House at Argenteuil* of 1873, his correspondence with Paul Durand-Ruel shows his financial dependence on his friend and dealer. As well as these difficulties, life at Argenteuil was troubled by more personal problems. Ernest Hoschedé, a close friend and wealthy patron, whose family Monet had visited at nearby Montgeron, moved abruptly to Brussels to escape the shame of his financial ruin, leaving his wife Alice to look after their six children and the auctioning of their estate. Unconventionally, the two families moved together to Vétheuil, away from Argenteuil which was becoming overpopulated and commercialized. It was here that Monet's second son Michel was born and Camille died of tuberculosis.

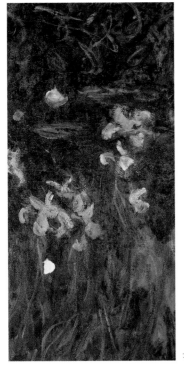

YELLOW IRISES, 1914-17

Desperate to find somewhere for his new family to live and for him to work undisturbed, Monet scoured the area surrounding the Seine at Vernon, eventually finding *Le Pressoir*, a pink house in the village of Giverny. It was here that he was able to create the perfect environment for his art, slowly converting a country house with a small orchard into the glorious artist's residence with what Marcel Proust was to describe as one of the 'six gardens of paradise'. With the help of some of the older children, the local Abbé Toussaint, who was a botanist, and his friends the painter Gustave Caillebotte and writer Octave Mirbeau, Monet gradually transformed and enlarged the garden to a stunning environment with countless views and motifs to inspire his art. It is important to note that the success of Monet's Giverny paintings is not due only to his ability to transfer what he saw before him onto the canvas, but also to his careful planning and arrangement of nature to provide subject matter. Monet planted flowers whose colours harmonized in accordance with the arrangement of his palette: golds and yellows next to blues and purples. Careful planning ensured a year-round profusion of colour, and if the weather was unsuitable for working outside, he could gather vases of flowers from which to paint inside one of the newly-built studios. Gone were the geometric designs of the previous owners' formal French garden, replaced by tumbling masses of monochrome blooms, Japanese plants, cherry trees and exotic orchids cultivated in a new hothouse.

By 1893 the garden was too large and complex for the artist to tend by himself. Félix Breuil, the head of six gardeners, was reputed to have clashed with Monet during their daily planning discussions as a result of differing priorities – the former seeing the need for correct procedures for pruning and caring for the soil, the artist more concerned with the aesthetic results – although ultimately they shared the same aim and love for the garden. It was at this time that Monet made what is perhaps the most famous alteration to the Giverny estate. Inspired by his lifetime love of water and his admiration for the Japanese ordering of nature according to ancient laws of harmony and balance, Monet created the waterlily pond. Composed with his painter's eye, he enlarged an existing pond by gaining permission to flood it

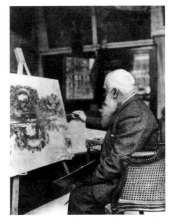

MONET AT WORK IN HIS STUDIO IN THE 1920S

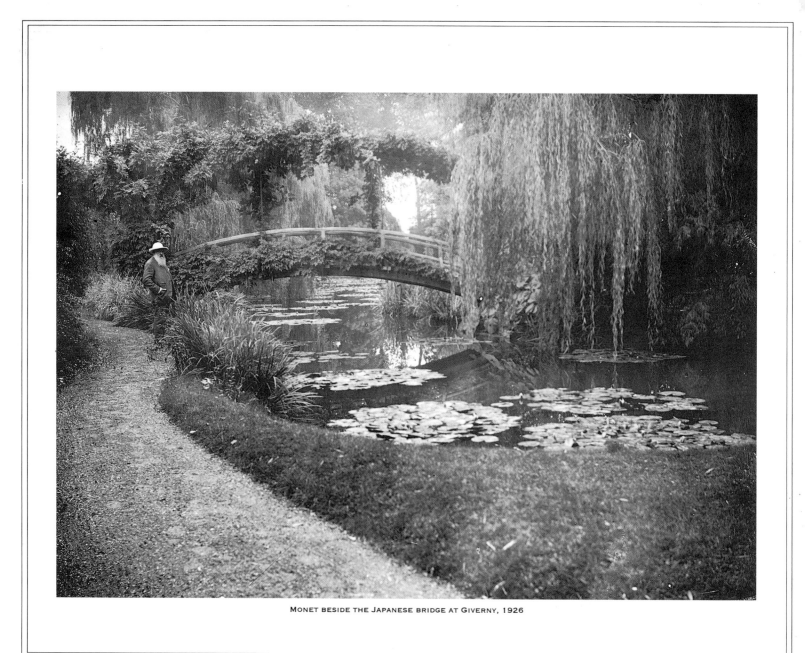

MONET BESIDE THE JAPANESE BRIDGE AT GIVERNY, 1926

with water diverted from the river Epte, surrounded it with aquatic plants and spanned it with a gently arched Japanese bridge. The resulting pond, with its floating islands of lily-pads and reflections of the surrounding trees and sky, was to provide Monet with the motif which concerned him for the rest of his life.

By the turn of the century Monet's success in selling his work meant that he was no longer leading the life of an impoverished artist, victim to the whims of the critics and buyers. Those who had accused him of undermining the very structure of what is acceptable in painting were now being won round to his methods of portraying what he saw with rapid, spontaneous brushmarks and applications of complementary colours. In 1909 Durand-Ruel sold all forty-eight paintings included in an exhibition entitled *Nymphéas: Paysages d'eau* within three days of its opening, at an average price of 4,000 francs. Gradually Monet's reputation as an innovative painter of nature both in Europe and the United States increased to such a height that Giverny became a place of pilgrimage for art lovers and aspiring painters. The small village where the peasants had

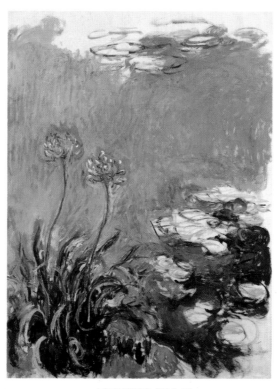

AGAPANTHUS, 1914–17

once regarded the Monet family as eccentric outsiders was inundated with painters, teachers and models setting up studios and filling the surrounding fields with *pleine-air* easels. Even the local innkeeper constructed studios on his roof and his wife became the local agent of a famous Parisian art materials supplier.

There are many existing photographs showing the white-bearded artist proudly escorting visitors around his garden, a tour he made himself at least three times a day. Only family, special friends, patrons and the occasional journalist were treated to this delightful spectacle after an informal lunch on the terrace of the house. One such journalist was Arsène Alexandre, who wrote a special feature in *Le Figaro* on 9 August 1901. Enchanted by the summer colour scheme of subtle harmonies of yellows and violets, Alexandre wrote that in his waterlily pond Monet had created a stunning *décor* which he in turn transformed with his brush and paints, 'Its surface rippling with large, round waterlily leaves and encrusted with the precious stones that are their flowers, this water seems, when the sun plays on its surface, like the masterpiece of a goldsmith who has combined the most

magical of metals.' In a sense it was the waterlily pond that was to give Monet a reason to continue painting after the disruptive years of the First World War. Previously only Monet's occasional bouts of bad temper and frustration with his work had disrupted the peaceful life at Giverny, but now the family was being broken up by illness and death within hearing of canon fire at the front. Alice Hoschedé, who had become Monet's wife on the eve of her daughter's wedding, died in 1911, leaving Monet too depressed to work.

Now in his seventies, Monet's own health was deteriorating and to his horror his precious eyesight was failing him. Georges Clemenceau, an important government minister, had become a close friend and admirer of the artist and it was through his support and encouragement that Monet embarked on his most large-scale project at such a late stage of his life.

Between 1914 and 1924 he was to work on the production of a series of panels of waterlilies with which to decorate specially designed rooms of the Orangerie in Paris. Often so dissatisfied with his work that he threatened to destroy it, and after a successful cataract operation which restored his sight, Monet eventually finished the scheme. The project had involved much political wrangling and hard work on Clemenceau's behalf, and the official inauguration did not take place until after the artist's death, but in its completion it acted as a donation to the state and, in its acceptance, as public recognition to Monet's contribution to French culture.

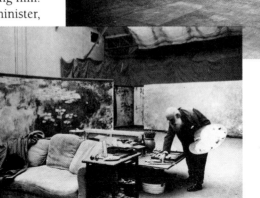

LEFT: MONET AT HIS WATERLILIES STUDIO AT GIVERNY, 1924-25
ABOVE: THE SERIES SOON AFTER INSTALLATION IN THE ORANGERIE, PARIS

Many saw the *Nymphéas* scheme as the successful culmination of a lifetime of experimentation and it was responsible for Monet's virtual apotheosis as the hero of Impressionism. Gustave Geffroy believed that on seeing the decorations no-one would be able to deny 'the power of conception and the force of genius of this man.'

THE PLATES

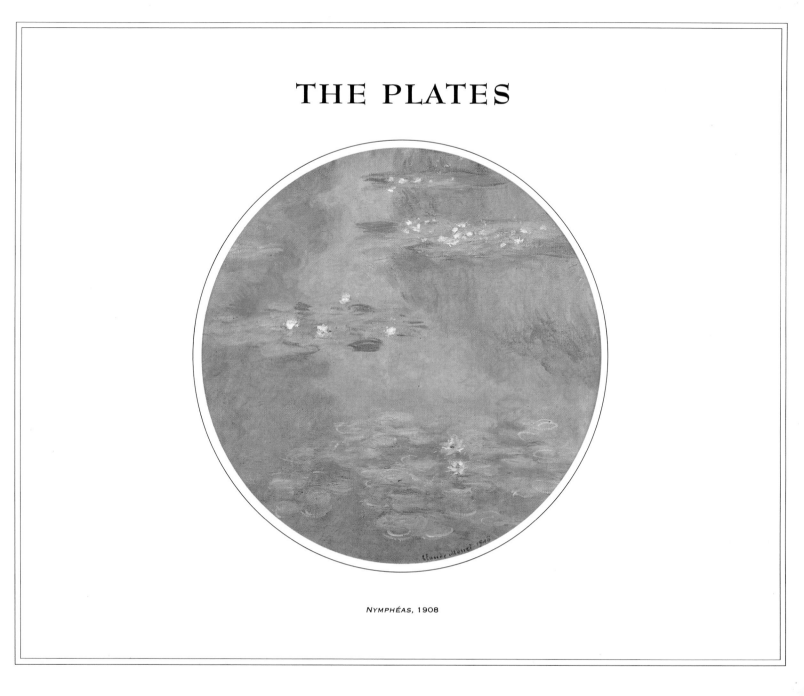

NYMPHÉAS, 1908

WOMEN IN THE GARDEN
——— 1866 ———
Musée d'Orsay, Paris

'This picture was actually painted from nature, right then and there, something that wasn't done in those days. I had dug a hole in the ground, a sort of ditch, in order to lower my canvas into it progressively as I painted the top of it.'

Monet, quoted in the Duc de Trévise's *Pilgrimage to Giverny*, 1927

'The sunlight falls directly on their brilliant white dresses; the tepid shadow of a tree cuts across garden paths, across the sunlit dresses, like a big grey table-cloth. No effect could be stranger. An unusual love for one's times is required to risk such a *tour de force*, with these fabrics divided into sunny and shady halves, and these ladies placed in a plot well groomed by a gardener's rake.'

Émile Zola, *L'Evénement*, 1868

Begun in the garden of a rented house at Ville d'Avray, and completed at Honfleur, this painting shows Monet dealing with a traditional theme in a way which even surprised his contemporaries. Although the women's dresses are detailed and defined to show how fashionable they are, the figures are integrated with their surroundings through the representation of light. The shadow, which creeps in from the right-hand foreground, spreads onto the seated woman's skirt to create an abstract blue shape, and in turn affects the colour of her face as she looks down to admire the flowers in her lap. Oval patches of pure light filter through the leaves of the tree onto the front of the standing woman's dress and the strong sunlight makes her companion's striped sleeve almost transparent. The painting was rejected by the Salon of 1867 but Frédéric Bazille bought it from Monet for 2,500 francs, which temporarily relieved the artist's financial situation. By 1921, when the French state approached him to buy it, Monet was in a position to demand 200,000 francs.

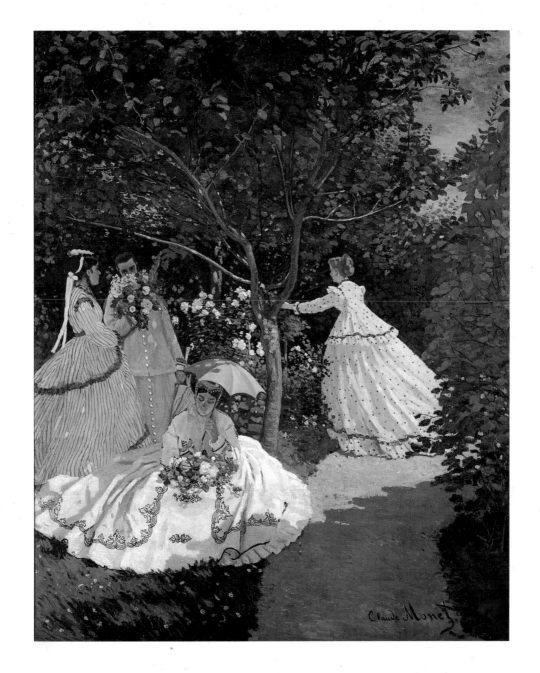

GARDEN IN BLOOM AT SAINTE-ADRESSE

——— 1866 ———

Musée d'Orsay, Paris

'Claude Monet has a special affection for nature that the human hand has dressed in a modern style. He has painted a series of canvases, executed in gardens. I know of no paintings that have a more personal accent, a more characteristic look. The flower beds, dotted with the bright reds of geraniums and the flat whites of chrysanthemums, stand out against the yellow sand of a path… I would love to see one of these paintings at the Salon, but it seems that the jury is there to scrupulously prohibit their admittance. But so what? They will endure as one of the great curiosities of our art, as one of the marks of our era's tendencies.'

Émile Zola, *The Actualists*, 1868

The support of the novelist Émile Zola in the early years of his career must have encouraged Monet, particularly because Zola was addressing similar themes in his own work. His series of novels about life in contemporary Paris was written in the *naturalist* style, which was the literary equivalent of Impressionist technique. Here Zola, acting as art critic, praises Monet's work for the modernity of his approach. We are in a specific garden whose owners are described by the well-tended flower beds and the corner of the house beyond the trees. Simply by painting a series of quite regular 'dots' of green and red paint, broken into only by the verticals of the tree-trunks, Monet manages to describe the different types of plants in the garden. But he also shares with us the light and the atmosphere at the specific moment that he experienced the scene, all overlooked by the wonderfully intense patch of blue sky.

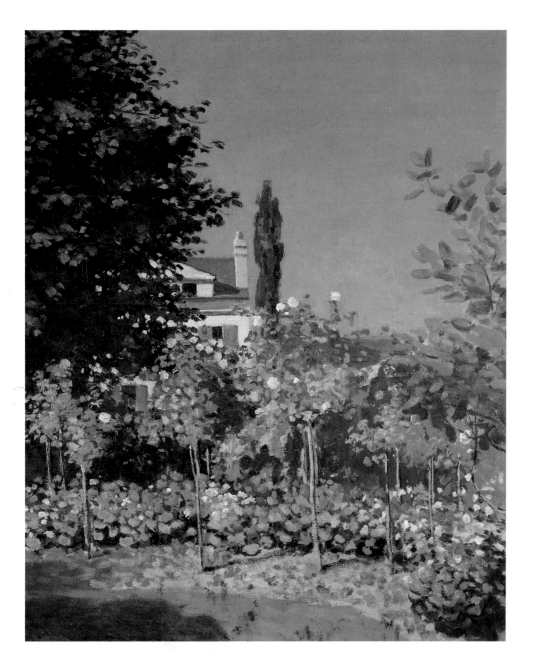

WOMAN IN THE GARDEN: SAINTE-ADRESSE

—— 1866 ——

Hermitage, St Petersburg

The series of pictures painted by Monet at his childhood home of Sainte-Adresse, which include the *Terrace at the Seaside* in the Metropolitan Museum of Art, New York, reveal the artist's middle-class background and way of life before he embarked on his career as a painter. In this image, the elegant young woman, Monet's cousin Jeanne-Marguerite, strolls through the carefully planned and beautifully tended family garden. Her white dress and graceful pose suggest a statue, adding to the scene's sense of timelessness which is disturbed only by the cast shadows which we know will shift as the sun moves around. Monet was obviously concerned with the effects of the light, shown by shimmering patches of yellow paint, but these images also describe a way of life in mid-nineteenth-century France, and it is this combination that made him a truly modern artist.

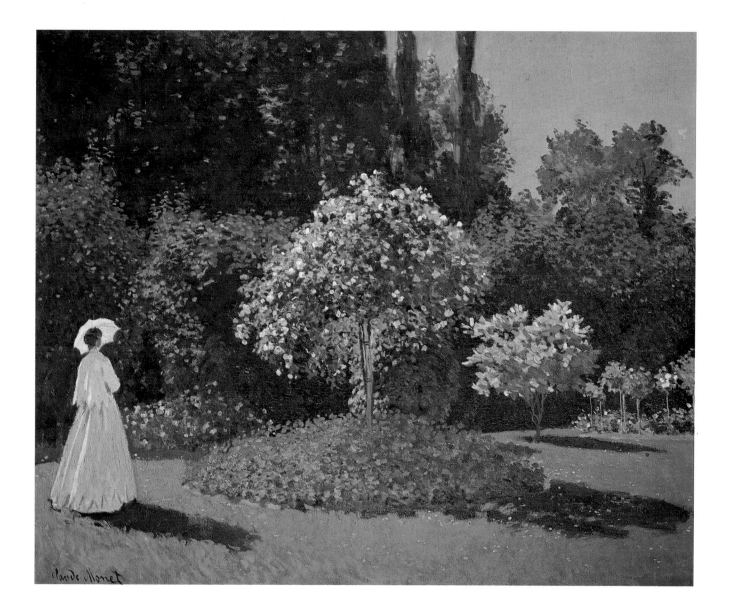

UNDER THE LILACS
—— 1873 ——
Pushkin Museum, Moscow

In 1871 Monet moved to Argenteuil with Camille Doncieux, whom he had recently married, and their four-year-old son, Jean. Paris had been greatly changed by the effects of the Franco-Prussian War and the Commune, and many people were leaving the city to find a more peaceful existence in natural surroundings. The pleasure and contentment experienced by the artist and his family during the early years at Argenteuil appears to be distilled in this painting, in which the play of light amongst the leaves and flowers of the lilac bushes creates a dream-like, almost magical quality. The forms of the two figures seated in the shade of the plants are broken up by the dappled sunlight, and we can almost share with them the drowsy atmosphere and scent of the lilacs.

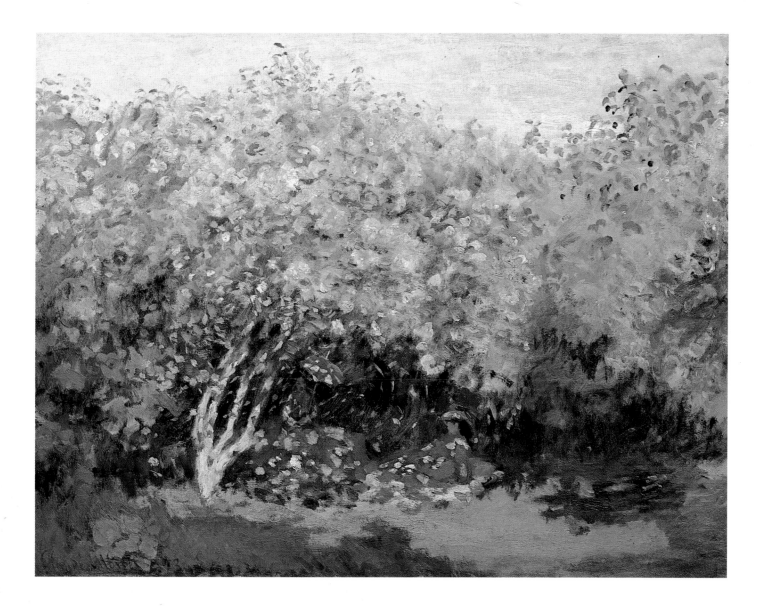

CAMILLE MONET WITH HER SON AND MAID IN THE GARDEN

1873

Bührle Collection, Zurich

In his 1876 book, *The New Painting*, the writer Edmond Duranty appealed to artists not to 'separate the figure from the background of the apartment or street; in life he never appears to us on neutral, empty or vague backdrops; rather, people should be seen in relation to 'a setting that expresses his wealth, his class, his profession.' Monet's paintings depicting life in the garden at Argenteuil fulfil these criteria by showing us contemporary figures whose lives are contextualized by their surroundings. Seated in the foreground, Camille meets the gaze of both artist and viewer with a somewhat neutral expression, and appears to block our access to the private world of the garden. Her proximity is expressed by her being placed so close to the picture plane, and by the cropping of her lower legs. The dark silhouette of her parasol, which is reminiscent of *The Beach at Trouville* of 1870, creates a dramatic contrast to the brightly-painted, sun-filled area beyond, separating the lady of the house from the maid who attends to her son.

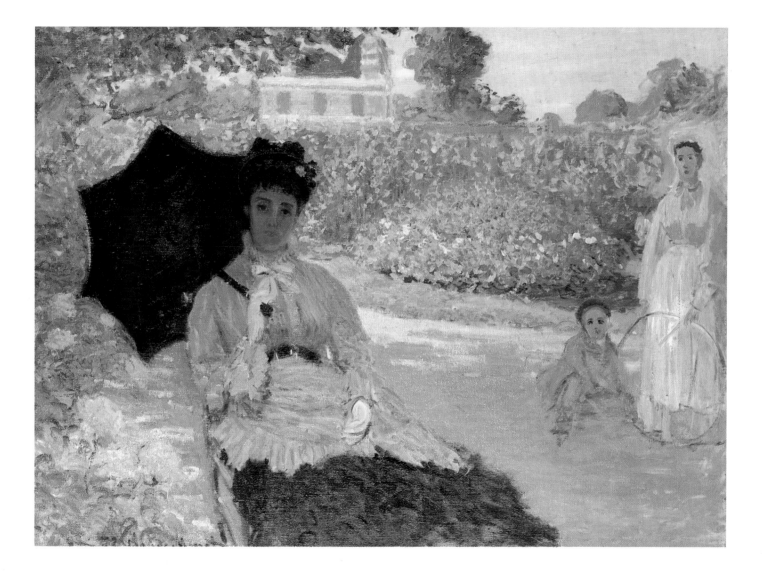

THE LUNCH

— 1873 —

Musée d'Orsay, Paris

Despite the apparent simplicity of this garden composition, the space in front of the screen-like wall of the house is full of detail and implied meaning. Unusually, the foreground area is in shadow which emphasizes the fact that the meal is over. Only Jean remains, playing on the ground next to the abandoned table, on which half-empty wine glasses and a silver coffee pot reflect the warm afternoon sunlight in quick touches of golden paint. The careful angle of the wicker trolley, echoed by the umbrella and basket, lead the viewer into the painting rather than closing the foreground off, and the sense of space is enhanced by the two women strolling in from the right. The depiction of a typical, everyday scene through broken brushmarks describing light and colour was becoming the unified aim of the group of artists who had trained together at Gleyre's studio in the 1860s, and meetings were held at Monet's Argenteuil house to establish their independent society.

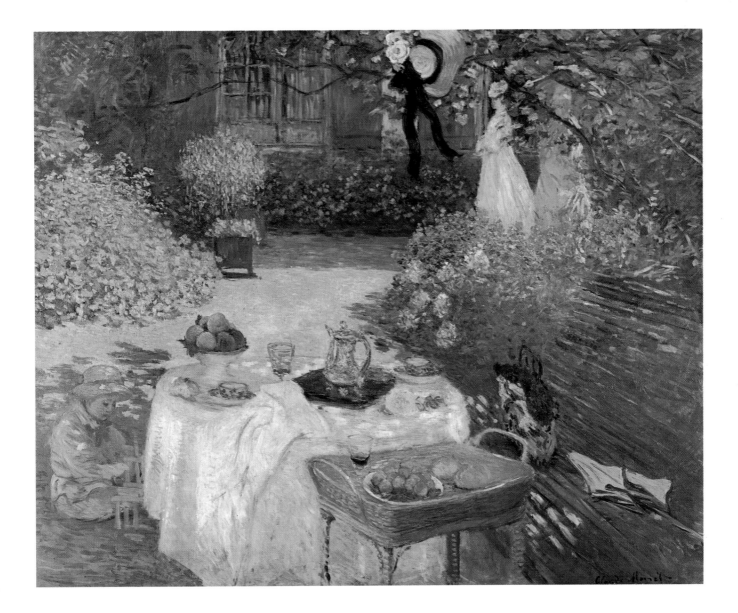

MONET'S HOUSE AT ARGENTEUIL
——— 1873 ———
Art Institute of Chicago: Mr and Mrs Martin A. Ryerson Collection

In this painting Monet celebrates the beauty of his garden and the tranquility of life at his home in Argenteuil. The side of the house and the flower beds on the left enclose the space and emphasize the privacy, with no evidence of intrusion or disturbance. But by the mid 1870s life in Argenteuil, and many other small towns like it, was changing dramatically. As more and more middle-class Parisians bought or rented property outside Paris it would have been impossible to live in isolation, and the Monets would have had neighbours intruding on their idyllic retreat. It has also been suggested that this painting reveals a strain in family relations; neither Camille nor Jean, with his back turned to us, addresses the artist or recognizes his presence, while the subdued palette and lack of activity imply the sense of boredom often experienced by people who have escaped from the city to the country.

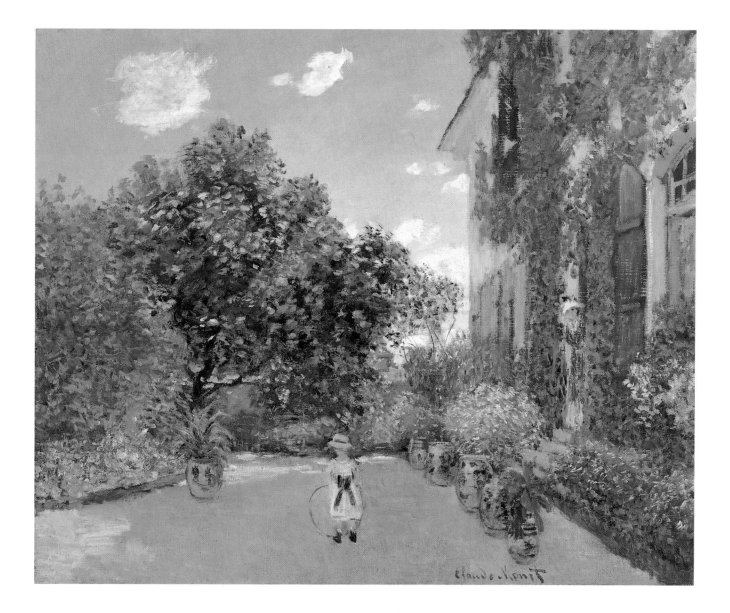

TWO WOMEN IN THE GARDEN
——— 1875 ———
National Gallery, Prague

'Monsieur Monet has some passionate touches that are marvellously effective... The consensus that unites [these painters] and makes them a collective force in our disintegrated age, is their determination not to seek an exact rendition but to stop at a general appearance. Once that impression is captured and fixed, they declare that their part is played... If we must characterize them with one explanatory word, we would have to coin a new term: Impressionism. They are impressionists in that they render not the landscape but the sensation evoked by the landscape.'

Jules Castagnary in *Le Siècle*, 29 April 1874

This article, which helped to give the Impressionists their name, was written in response to the first exhibition of the *Société Anonyme des Artistes*. Other less sympathetic critics felt that the paintings' lack of finish not only undermined the content but also ridiculed the viewer, who had paid his money to see highly worked and smooth surfaced images. In this picture the appearance and mood of the garden scene is achieved through a rapid application of paint, where each individual brushmark made by the artist is visible. There is also a humorous quality in the floating head of the woman who is completely submerged in the dahlia bush.

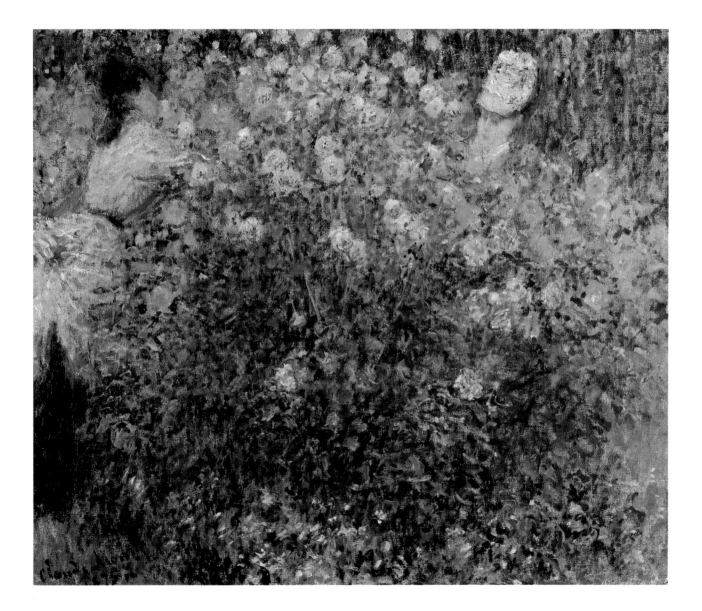

A CORNER OF THE GARDEN AT MONTGERON

——— 1876 ———

Hermitage, St Petersburg

'It was in 1876 that I saw Monet for the first time. I was only eleven years old, but I remember well his arrival at Mongeron at my parent's house. He had been described to me as a tall artist with long hair. That impressed me, and I quickly grew fond of him, for one could feel that he liked children. He was a great tease. He thus arrived at Montgeron, where he stayed for some time to paint.'

Jean-Pierre Hoschedé, *Claude Monet ce Mal Connu*, 1960

Monet's friendship with the Hoschedé family who he visited in Montgeron was to have a profound effect on the young boy's life. After the collapse of his father's business, and his self-imposed exile to Belgium, the families moved in together, and Alice became Monet's companion and wife after the death of Camille in 1876. Jean-Pierre shared the artist's love of plants and, with Michel Monet, wrote an account of the flora of the area around Giverny. Encouraged by his step-father and the local priest, who was also a botanist, he experimented in the cross-breeding of flowers, and went on to study agriculture at college. Monet's vibrant painting, with its varied brushmarks and jewel-like colours, shows the beautiful family garden that must have inspired him.

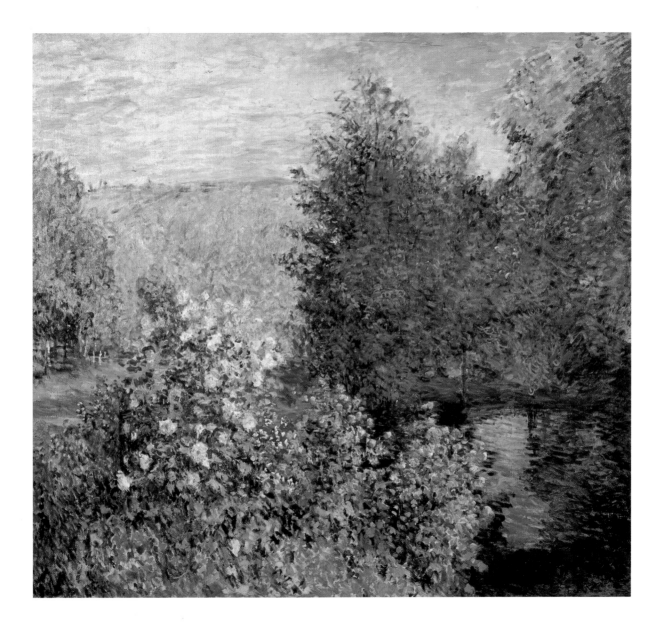

GLADIOLI

———1876———

Detroit Institute of Fine Arts

With its complexity of brightly-coloured brushstrokes, the surface of this painting is like a richly decorative hanging. Monet has woven the marks together, building up the three-dimensional image without destroying the sense of pattern on the picture surface. In some areas he even leaves the texture of the canvas exposed, incorporating it into the image to explain the warm tone of the ground. There are many different types of marks – the blue diagonals of the trellis, the vertical stems of the gladioli and the dry horizontals of the path – which serve both as an explanation of the nature of the objects and as a means of communicating the artist's experience of the scene before him. His technical skill can be seen in the way in which he enhances the sense of space by simple 'Vs' of white paint which are butterflies illuminated by the strong sunlight, without which the depth would be reduced. Once again Monet has composed a garden painting in which a woman admires the beauty around her and we, in turn, are invited to admire hers.

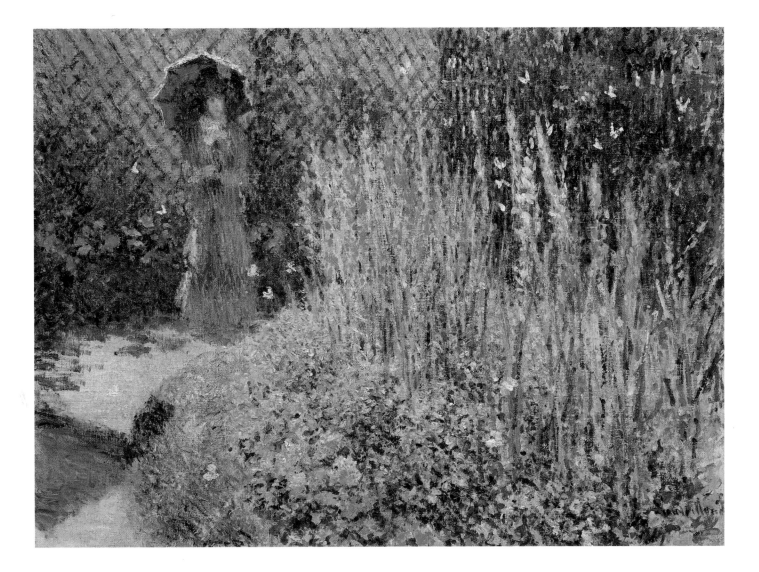

THE PARC MONCEAU, PARIS
——1876——
The Metropolitan Museum of Art: Bequest of Loula D. Lasker, NYC, 1961

'Rue la Peletier is having a streak of bad luck. First there was the fire at the opera, and now disaster has struck the area again. An exhibition, said to be of painting, has just opened at Durand-Ruel's. The innocent passer-by, drawn by the flags that adorn the gallery's facade, enters, and a cruel sight greets his terror stricken gaze. Five or six lunatics, including one woman – a group of wretches touched by the madness of ambition – have joined to show their work there. Some people just burst out laughing at he sight of these things, but they just leave me heartsick. These self-declared artists style themselves the intransigents, the impressionists; they take canvas, paint and brushes, throw some colour on at random, and sign the result.'

Albert Wolff in *Le Figaro*, 3 April 1876

This vehement and brutal attack on the work of the Impressionists was characteristic of some of the negative responses to the group exhibition of that year. Wolff objected to paintings like Monet's where the artist's experience of a scene was communicated through direct application of colour to the canvas, but he ignored the subtleties of the compositions and their careful representation of the contemporary world. In Monet's images of the Parc Monceau, which he painted whilst staying with the art dealer Victor Choquet, we see an elegant public park based on English gardens, which provided Parisians with a means of escape from the increasingly crowded boulevards.

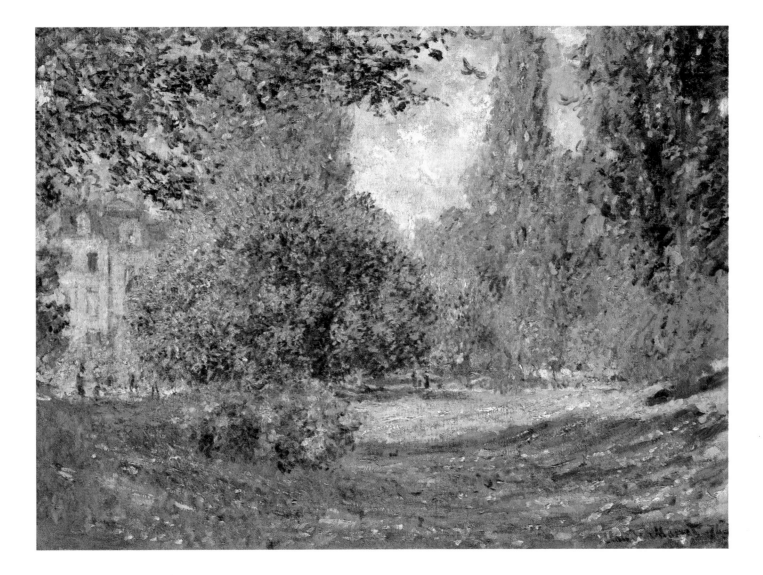

BORDIGHERA, THE GARDENER'S HOUSE
————1884————
Private collection

'So things are progressing quite well, although it's hard going: those palm trees make me curse and swear; and the motifs are terribly hard to get hold of and put down on canvas; everywhere is so luxuriant; it's gorgeous to behold. You could walk on for ever under palms, orange and lemon trees and also under the splendid olive trees, but things are not so easy when you're looking for motifs. I'd like to paint some orange and lemon trees standing out against the blue sea, but can't manage to find any the way I want them… As for the blue of the sea and sky, it's beyond me.'

Monet, letter to Alice Hoschedé, 26 January 1884

The daily correspondence between Monet and Alice Hoschedé, while he was on a painting trip to the Riviera, reveals his frustration with his work and her doubts about their relationship. Although the letter here expresses an inability to transfer onto canvas all the beauty of the scenery he saw around him, the many paintings he produced show the success of the project. Here the dry, almost chalky paint used to paint the sky beyond the screen of dense foliage, conveys the extreme heat and sunlight which was so strong that it caused the artist's clothes to fade.

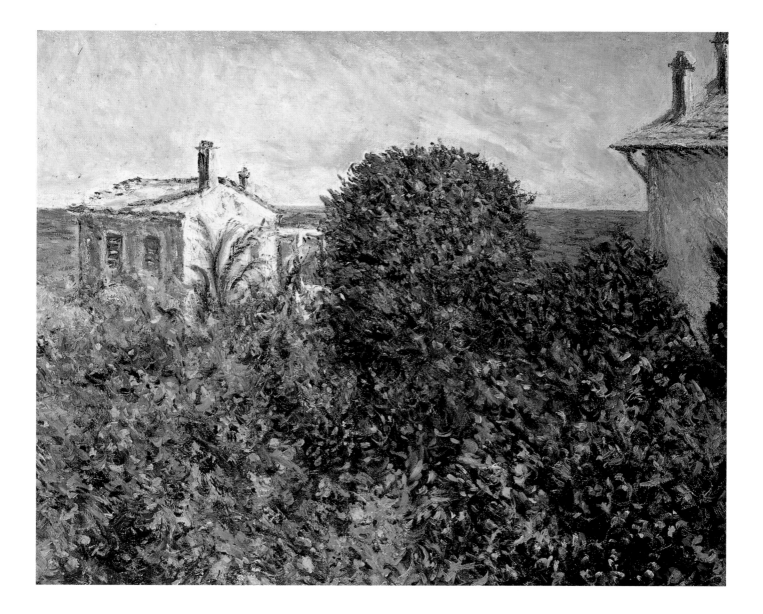

IN THE GARDEN
—— 1894 ——
Bührle Collection, Zurich

'It is summer. On either side of the sandy path, nasturtiums of every hue and saffron eschscholtzias collapse into dazzling heaps. The surprising fairy-tale magic of the poppies swells on the wide flower beds, covering the withered irises; it is an extraordinary mingling of colours, a riot of pale tints, a resplendent and musical profusion of white, pink, yellow and mauve, an incredible rolling of blond flesh tones, against which shades of orange explode, fanfares of blazing copper ring, reds bleed and flare, violets disport themselves, black-purples are licked with flame.'

Octave Mirbeau in *L'Art dans les Deux Mondes*, 7 March 1891

This poetic description of Monet's garden by the Symbolist writer Octave Mirbeau was one of the many published accounts made by contemporary visitors to Giverny. In the decade since the family's move to the pink-stuccoed house, which the artist bought from the landlord in 1890, Monet had developed the original more formal garden into a stunning arrangement of flowers, pathways and ponds, with the help of his many children, friends and, later, hired gardeners. This painting, in which yellows and orange flowers predominate, shows how the garden was organized with close reference to the arrangement of the artist's palette.

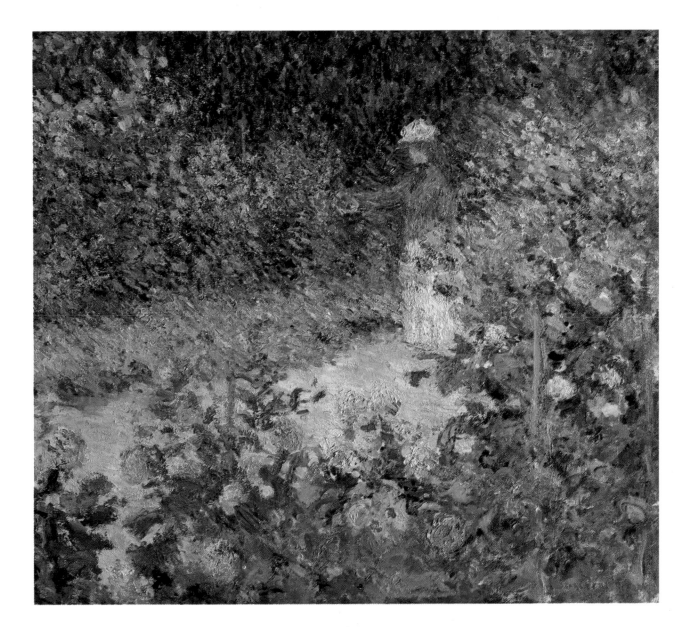

CHRYSANTHEMUMS

—————1897—————

Kunstmuseum, Basel

Monet's passionate love for flowers, to which he attributed his desire to become an artist, can be understood from the contemplation of paintings such as this. The daring way in which he completely fills the entire canvas with this close-up of blooms creates a dramatic and unusual decorative image. There are no edges to the composition, which implies that the flowers shown are only part of a mass, which is how Monet planted his garden. The various types of chrysanthemums are shown, but as part of a unified scheme, where individual flower heads reflect the colours of those around them against a backdrop of dark blue-green.

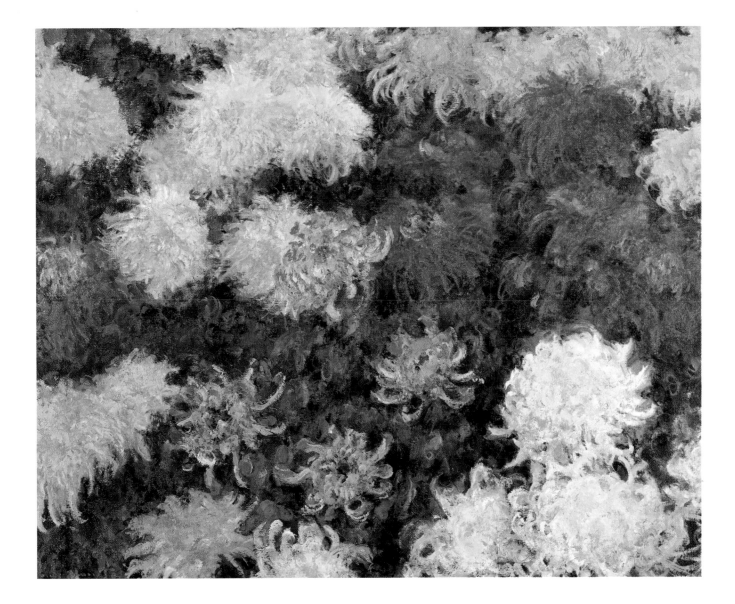

WATERLILY POND
—— 1899 ——
National Gallery, London

'Once again I have taken on something impossible; water with grasses undulating on the bottom… it is wonderful to look at, but maddening to want to render it. But then I am always tackling something like this!'

<div align="right">Monet, letter to Gustave Geffroy, 22 June 1890</div>

With this self-deprecating comment to a close friend, Monet marked the start of the project which was to obsess him until his death, and from which some of the best-loved and most well-known paintings in the history of art were to result. The Japanese bridge, gently spanning the water lily pond with its constantly changing reflections, provided Monet with a motif which he was to paint many times. In this version the calm, mirror-like water reflects the willow trees so clearly that only the lily pads indicate the surface of the pond. The canvas is completely filled so that the light and weather condition are only understood in relation to the highlights and colours. This effect is combined with the bridge's position parallel to the picture plane, to create an abstracted image similar to some of the Japanese prints which Monet hung in his home.

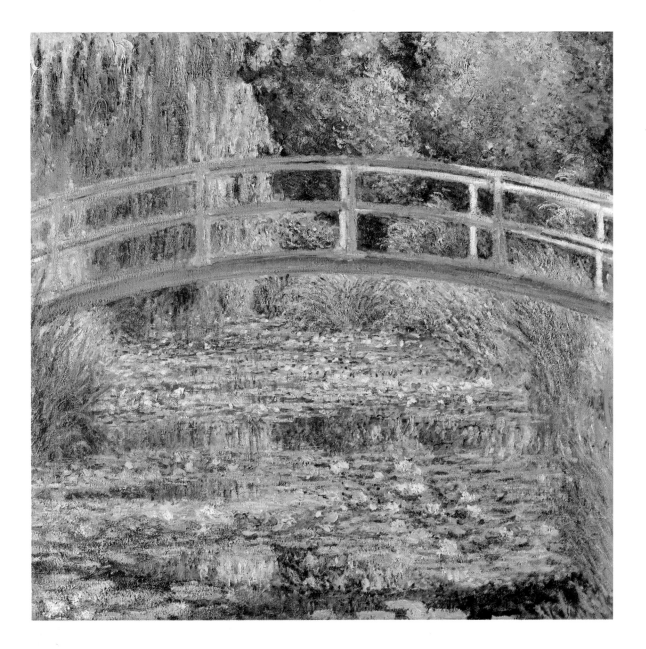

THE ARTIST'S GARDEN

————1900————

Musée d'Orsay, Paris

The metre-wide flower-beds of *Irises germanica* which bordered the central walkway up to the main house show Monet's love for masses of a single flower as opposed to more formal garden organization where different flowers were combined in careful groups. The effect of such beds can be admired in this painting where the diagonal composition and the cropping of the pathway leads our eye into picture, and we share the artist's enjoyment of his garden. We can also imagine the smell of the irises, and the transition from the shade into a patch of warm sunlight, all described by the application of thick dabs of purple and violet paint. Monet's ability to portray nature with such success was often attributed to a superior optical physiology, a theme used metaphorically by the Belgian writer Georges Rodenbach: 'Monet is above all an eye, a marvellously sensitive retina, an eye which has in time developed a tangle of nerves, like a magical telegraph which communicates with all the nuances of the air.'

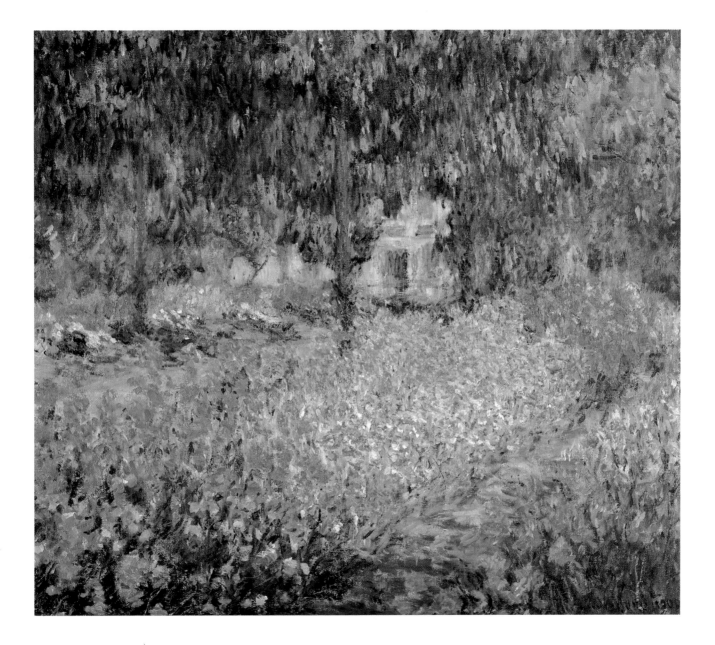

THE ARTIST'S GARDEN AT GIVERNY

———— 1900 ————

Yale University Art Gallery: Gift of Mr and Mrs Paul Mellon

'Sowing: around 300 pots Poppies – 60 Sweet pea – around 60 pots white Agremony – 30 yellow Agremony – Blue sage – Blue Waterlilies in beds – Dahlias – Iris Kaempferi. From the 15th to the 25th, lay the dahlias down to root; plant those with shoots before I get back. Don't forget the lily bulbs. Should the Japanese peonies arrive plant them immediately if weather permits, taking care initially to protect buds from the cold, as much as from the heat of the sun. Get down to pruning: rose trees not too long, except for the thorny varieties.'

Monet, letter to Félix Breuil

In 1900 Monet travelled to London, where he made a series of paintings of the River Thames, and it was presumably before this trip that he wrote the long letter to his head gardener Félix Breuil with a list of detailed instructions for the care of his precious garden. The intricacy of these instructions proves how closely involved he was in the upkeep and development of the garden. This picture of another path surrounded by irises, shows how Monet worked on the same motifs many times, but never failed to portray the familiar scene with freshness and renewed vitality, by being acutely sensitive to the changes in the light and in his own mood.

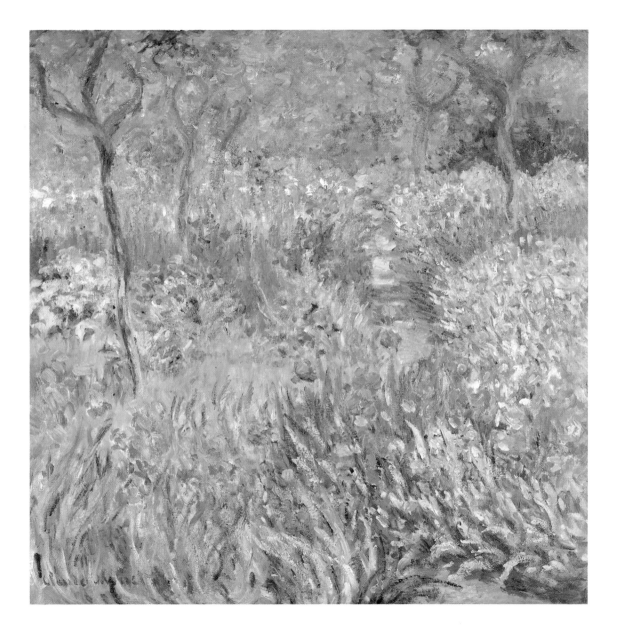

THE GARDEN
—————1902—————
Österreichische Galerie, Vienna

'The same man we find to be somewhat laconic and cold in Paris is completely different here: kindly, unperturbed, enthusiastic… This, then, is why I say that the garden is the man. Here is a painter, who, in our own time, has multiplied the harmonies of colour, has gone as far as one person can into the subtlety, opulence, and resonance of colour. He has dared to create effects so true-to-life as to appear unreal, but which charm us irresistibly, as does all truth revealed. Who inspired all this? His flowers. Who was his teacher? His garden.'

Arsène Alexandre in *Le Figaro*, 9 August 1901

The reputation of both garden and artist was increasing in strength at the turn of the century. Monet had ended his brief disagreement with his dealer Paul Durand-Ruel, and had exhibited his series paintings in the United States, Venice and London. Giverny was inundated with visitors from around the world but only the lucky few were given the chance to see Monet's home and garden, escorted by Monet himself. In this view of the main walkway leading to the terrace where visitors ate lunch with the family, the diagonal strips of intensely coloured flowers create a dramatic spatial recession, presenting the house as the spiritual and visual heart of the estate. It was also in 1902 that Alice Hoschedé became the second Madame Monet.

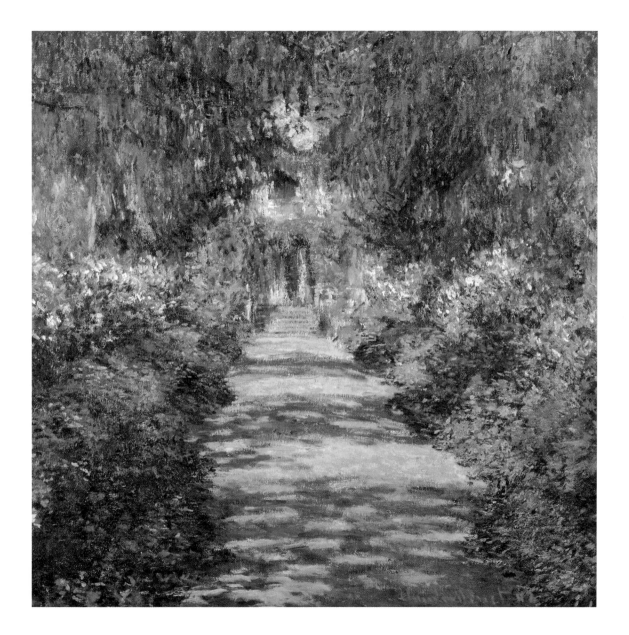

WATERLILIES

—— 1905 ——

Museum of Fine Arts, Boston: Gift of Edward Jackson Holmes

In the early years of the twentieth century, Monet continued to work on various series of paintings – his *Haystacks, Rouen Cathedral* and *Poplars* – returning to a motif time and time again in order to capture its essential qualities and to examine it in different atmospheric conditions. Here the representation of waterlilies has been refined to an almost abstract surface pattern of subtle harmonies of pale green and mauve, interrupted only by the yellow and pink dabs of the paint which describe the flowers. Paul Durand-Ruel organized various exhibitions of the *Nymphéas: Paysages d'Eau* which he sold for Monet at extremely high prices.

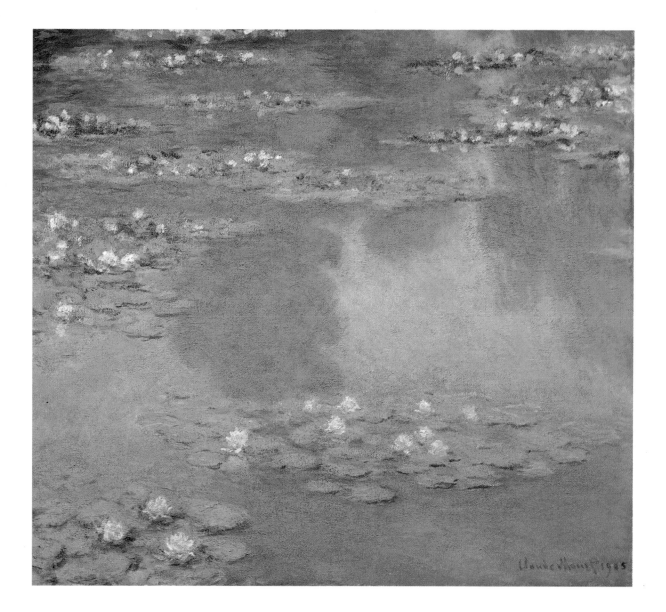

PEONIES
—1910—
Galerie Beyeler, Basel

Beneath the shelter of straw canopies, a mass of bright red and pink peonies appear to burst into flame. A variety of directional marks describe the flowers and seem to express the artist's energy and enthusiasm in front of his chosen scene. Monet worked very quickly, often finishing a number of canvases in one day's work, which would begin very early in the morning and end only when the light began to fade. He would fly into a rage if bad weather prohibited him from working outside and built sky-lit studios attached to the main house in which to continue painting when it rained. But it was when seated undisturbed at his easel, shaded from the sunlight by a hat or parasol, that Monet was happiest creating stunning paintings such as this, which capture the intensity of both his visual and emotional experience.

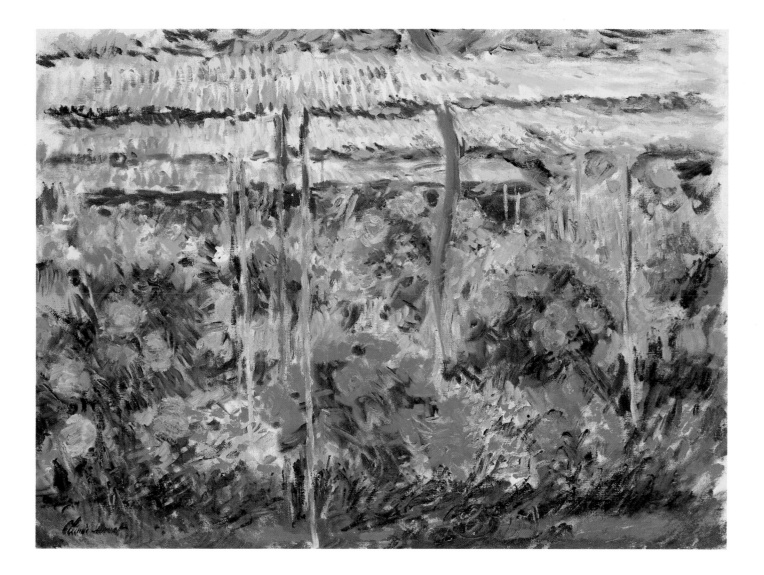

THE FLOWERING ARCHES
————1913————
Phoenix Art Museum

At the time that this painting was made Monet was suffering from bouts of depression caused by the gradual loss of members of his family and many of his friends. His eldest son, Jean, was suffering from a nervous disorder which greatly affected his personality and from which he died early in 1914. Monet found solace in his garden, and when he felt strong enough he continued to paint his favourite scenes. In this unusual view, he has moved his attention from the surface of the waterlily pond, which had been extended, and looks towards the flower-laden arches and horse chestnut trees on the opposite bank. Although the style in which he paints the arches refers back to earlier paintings, he is still enjoying the game of three-dimensional space portrayed on a flat canvas and reflects the curving shapes in the water to create an abstract pattern.

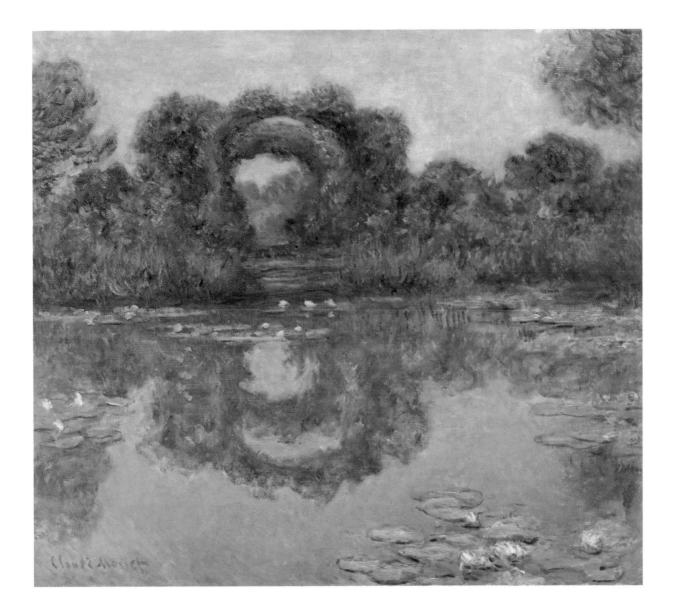

WATERLILIES:
THE TWO WILLOWS
——— Detail, 1914–18 ———
Orangerie, Paris

OVERLEAF
WATERLILIES:
GREEN REFLECTIONS
———1914–18———
Orangerie, Paris

'A sequence of delicate transitions leads us from the direct image to the reflect-ed and over-reflected image, through diffusions of transposed light, whose values merge and part in a single harmony. It is a matchless field of brilliant exchanges between sky and earth, crowned by a feeling for the world that lifts us to the heights of the unending communion of things, in the supreme fulfil-ment of the senses.'

Georges Clemenceau, *Claude Monet*, 1929

These are the words of the politician and great friend of the artist who had been responsible for the instalment of the scheme of waterlily paintings in the Orangerie of the Tuileries in Paris. The series of panels painted on huge rectan-gular canvases in a specially-constructed studio at Giverny, were donated by Monet to the state and the official bequest took place in April 1922. These two examples of the *Décorations* show the diversity which Monet achieved despite the limitations of the subject matter: whereas one shows pale, almost cloudy water framed by the gentle curves of the willow tree trunks, the other is a darker, more dramatic image suggesting the depths of the water beneath the jewel-like flowers and rippling reflections.

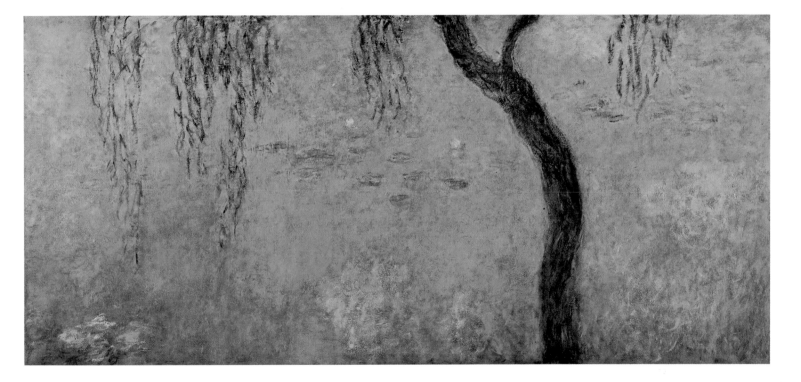

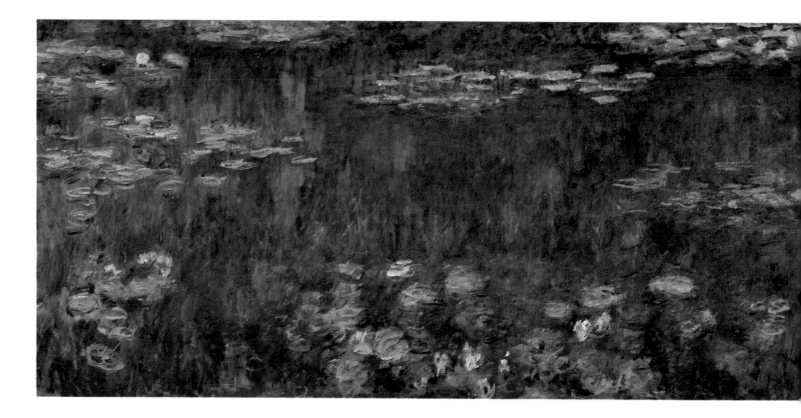

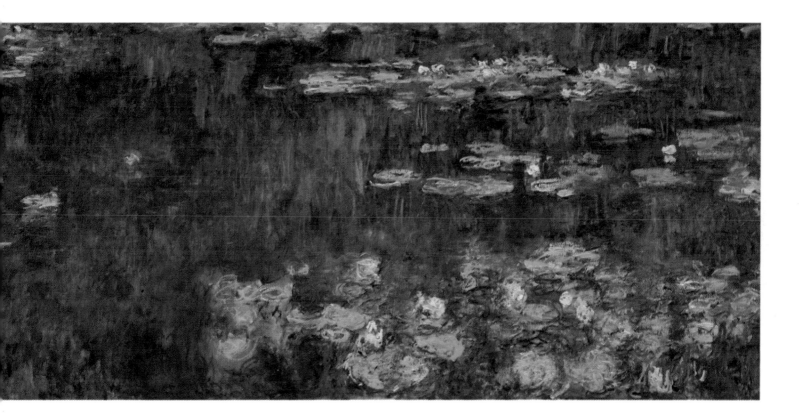

THE ROSES
———— 1915–22 ————
Musée Marmottan, Paris

In 1924, near the end of his life, Monet told a visitor to Giverny: 'My garden is slow work, pursued with love and I do not deny that I am proud of it. Forty years ago, when I established myself here there was nothing but a farmhouse and a poor orchard… I bought the house and little by little I enlarged and organized it… I dug, planted, weeded myself; in the evenings the children watered.' Although he altered and developed the estate according to his large scale and long-term schemes, Monet always paid close attention to details, checking the plants and soil on two daily inspections of his gardens. Likewise, in his art, he constantly learned from the close observation of individual species, as in this painting where he has captured the relationships between the colours and forms of the flowers, leaves and the sky beyond.

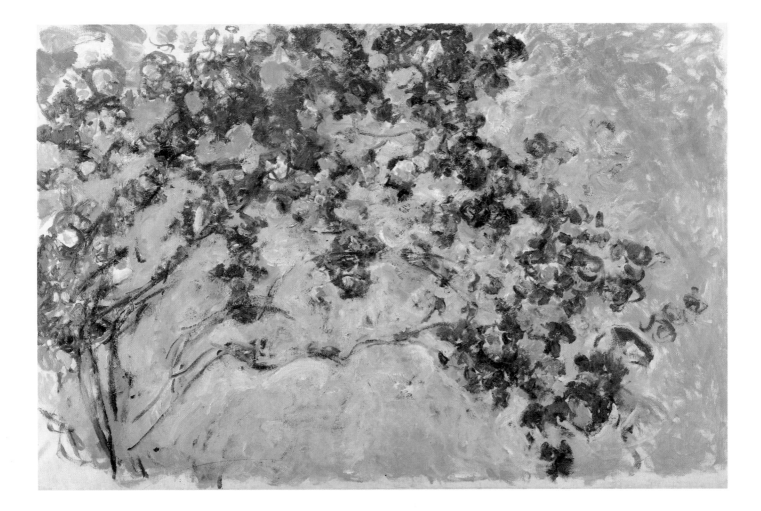

THE IRISES

1915–22

Musée Marmottan, Paris

Having been accused of madness and of throwing paint at the canvas in the early years of his career, Monet's approach was now not only praised by the art critics, but was being used as a starting point by a whole generation of young artists such as Matisse, Gauguin and Seurat. These painters had great respect for Monet, for they saw him and his fellow Impressionists as having liberated art from the hierarchical rules of the Academy and Salon system. This painting provides an example of this break from tradition, for by focusing on a small clump of leaves and flowers Monet has abandoned complex composition and allows himself to concentrate on the essential qualities of light, colour and texture. The exposed canvas and 'unfinished' lower edge of the canvas would have been completely unacceptable in official terms forty years earlier, as would the irregular surface of the top layer of paint, where the delicate flowers extend into real space beyond the canvas.

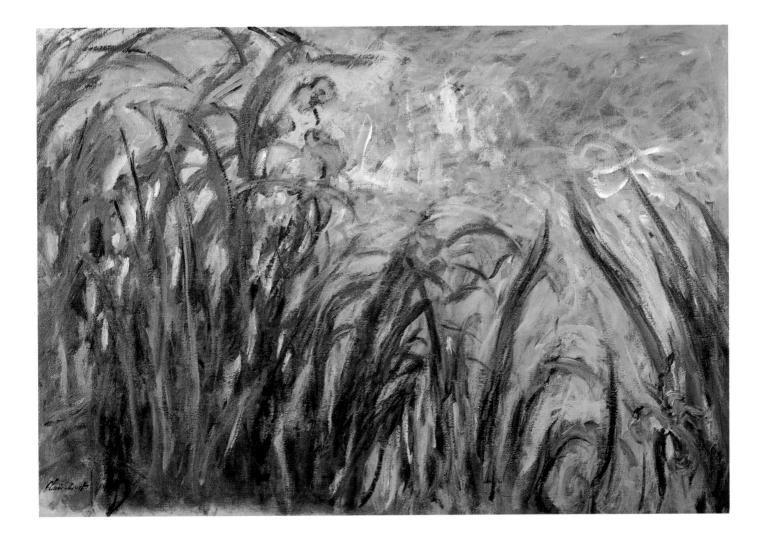

WATERLILIES

————1916–19————

Musée Marmottan, Paris

Throughout his career Monet developed an increasingly complex dialogue between reality and the image. He had always believed that it is impossible for an artist to deny his or her role in the conception and making of an image, essentially seeing art as subjective both in terms of the artist and the viewer. In a sense, the waterlily paintings challenge our perceptions of reality, and do not allow strict definitions of what is real or image, solid or reflected, paint or canvas. Here the willow leaves trail on the surface of the water creating a continuous vertical screen and only the small green triangle describing the bank helps us to place ourselves on solid ground.

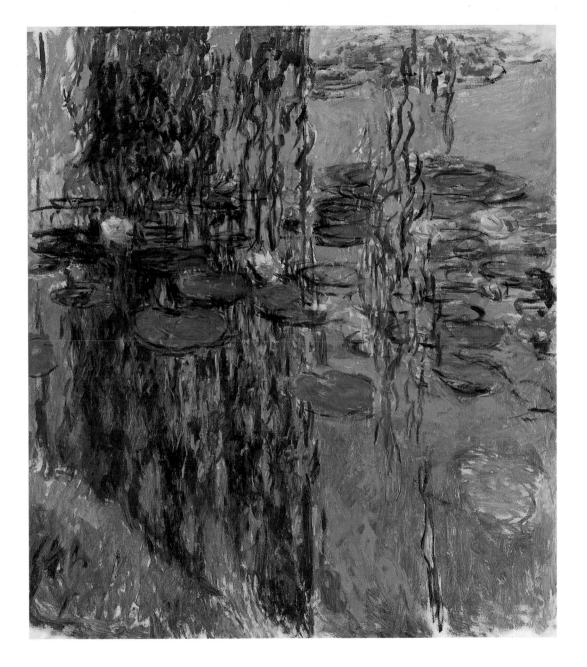

First published in Great Britain in 1994 by
PAVILION BOOKS LIMITED
26 Upper Ground, London SE1 9PD

Text © Georgia Sion 1994

Conceived, edited and designed by Russell Ash & Bernard Higton
Picture research by Mary-Jane Gibson

A CIP catalogue record for this book is available from the
British Library.

ISBN 1 85793 285 4

2 4 6 8 10 9 7 5 3 1

Printed in Spain by Cayfosa, Barcelona

This book may be ordered by post direct from the publisher.
Please contact the Marketing Department.
But try your bookshop first.